JAMES SIENA

D0861410

PAINTING

JAMES SIENA

January 11 – February 9, 2019
537 West 24th Street, New York

PACE

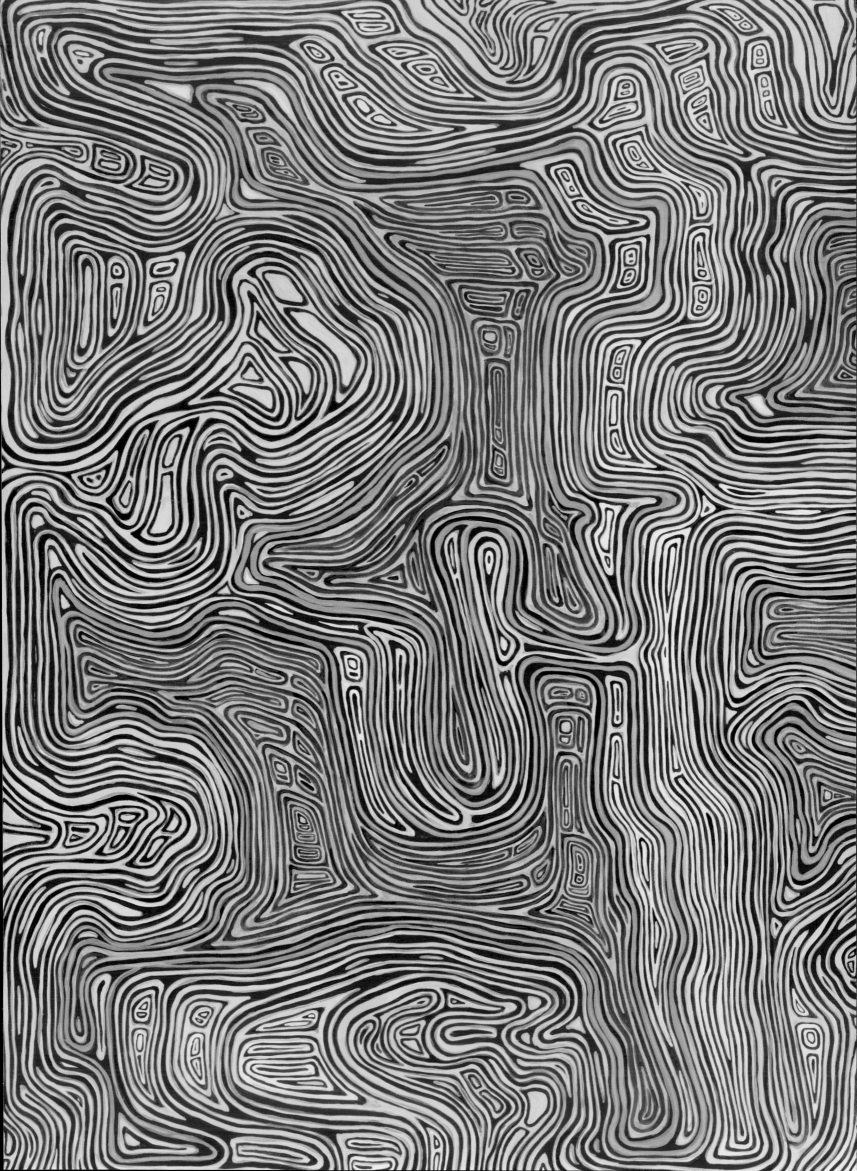

Marjorie Welish

Decisions, Decisions, Decisions

So, let us begin: an irregular perimeter drawn on canvas reverberates throughout the abstraction. That is to say: the perimeter is generative of the whole work, for within this irregular perimeter, another line accommodates the established irregularity, yet moves at its own initiative.

And yet again: set within and accompanying the doubled line of the periphery comes another line, varying the interval, with an informality pleasurable to see at close range.

Now let us step back.

James Siena's recent art alters the terms of his practice in several significant ways. What remains the same is the given graphical impetus and the methodological control set down at the outset to play out in iterative restatement. What has changed are the format and technique: to paint the graphical scheme large from the start—not merely enlarged. Working on large canvases demands rethinking technique. Seen from afar, these forcefully graphic images are designed to signal the outer edge instantly, as though to say, enter here. The outline commands attention as it is a forceful separator from the margin, the stylized, inset flouncing line so utterly different from the straight-edge canvas support. But the expanse within the outlying outline is sensitized to touch, decisively calibrated to a very rare degree. Siena has now split his technique between the graphic impact of the large format and all else that develops from there.

By polarizing graphical and calligraphic technique, Siena can retain a structural clarity of design even as the structure is ramified, intensified, and complicated through bending contours, shifting terrain, and oscillating drifts that disorient and reorient the eye. To control the unfolding complication, he first draws not only the perimeter of each unit but also the basic internal

scheme that, as with cell membranes, stabilizes a situation without fully predicting the specifics. Indeed, this second major change, of the many variables introduced, requires a clarity of the structural pattern.

Percussilative Echo (2017–18; p. 12) and also *Hexscilloid* (2018; p. 16), its madcap cousin, reveal Siena's decision-making apparatus, fully articulated yet ever-vigilant as the composition develops from side to side, from outer edge inward toward reticulation. Siena is known for his controlling linear finesse that sustains surface tension. In this body of work, the pliable liquidity of acrylic brushwork and the flexibility of the canvas support induce a variable informality in technique unusual for the artist and worthy of attention stroke by stroke. The brushwork allows for varying marks, and even more so the spacing between them. This set of contingencies imposes a paradoxical constraint: the variability of gestural marks and their spacing must resolve the problem of equilibrium. To accomplish this, Siena manages the flow, inducing a drift—and even a bias to the composition—often from right to left. Meanwhile, he alternates wide to narrow spacing within each figure, planted with cellular infill that rotates inward to occupy the spaces. This reciprocal back-and-forth is easy to see in *Hexscilloid* because the color-coding traces the sequence of collapses; yet, the specific scoring of moves within each of the six figures also propels the inner perturbations. A self-imposed freedom troubles Siena's method by inducing oddities and irregular fibrillations.

Back and forth, side to side, the accumulating lines work their way inward from the periphery. In this body of work are canvases that, though also developing inward, range from the sparse to the dense to show the range of possible approaches. There is none of his well-known fractal-like sequencing in series, initiated for our collaborative book *Oaths? Questions?* (Granary Books, 2009), to which he and I contributed both images and text. As against this sequencing, these works—and *Hexscilloid* quite conspicuously—display developmental tactics all at once, as declarative as they are eccentric.

How to evade cleverness is at issue here, as it must be with any formalism writ large, broadcasting its own devices and sign language. The way out is *through*: dedicated thoroughness, to the point of no return. The resultant art then evinces experience: the engaged work in the process of unfolding its method, which is one way out of the foregrounding of a device. Siena's current body of work especially does this in conjunction with a

marked increase in the number of variables introduced into the method: from painting attentive to spacing at odds with symmetry, to a recursive back-and-forth, all the while closing in to fill cells and to draw tighter and tighter binding, as intuited, experiential forces create mental interference patterns with the given program.

In tracing a large figure within a small field, Siena magnified and simplified the tactics of *Hexscilloid* for *Spoolstone* (2017; p. 18), yet the latter seems to enjoy a perverseness of disproportionate relations. The generative line makes a point of its internal figure-ground tension: the figure is so enlarged as to approach Lewis Carroll's Alice as exceeding the room in which she found herself. Relative size is the element at work in Siena's painting, and it is especially effective in that the ground itself is not empty. In *Spoolstone* the yellow ground is by no means a mere colored background, but is rather silted with lines that take the composition to the very edge of the canvas support.

In the large canvases blending figure and ground, the greatest intensity conjoined with the greatest complicating subtlety obtains, for their line and field share the same hue and interact within the narrow chromaticism available. Enhanced through subtle interactions across the surface, the artist's signature graphic design is pronounced in *Urretru* (2018; p. 32). Drawing and painting merge through the shared earth tones of yellow ochre and burnt sienna. Oscillating bands beneath the drawing inform the calligraphic disposition of line and even more the field's fluctuating percussive development. This phenomenon needs to be viewed at close range, not because of unintelligibility from afar but because impact is not at issue in this slow and cumulative study. It is not unlike a Chinese vertical scroll, which tolerates no revision of the mountainous cloud and rock formations. Earth and sky may be universals, but the rendering in ink of these known natural elements makes them palpable to experience. In Siena's *Urretru*, a rippling calligraphy and the chromatic surface, a graphic line and tonal wash, likewise animate and reanimate each other: an eccentric edge requires vigilant processing as it progresses through changes in hue close in value.

Having established that, Siena tries something else. If *Urretru* is a sustained steadying of close-valued figure and ground, in the red world of cadmium red light and deep, which we find in *Ssonsunurrhth* (2018; p. 38), the graphic line that wends its way goes on an odyssey. As in such journeys, the purpose is to lose one's way, or at least to test the bounds of sense by approaching

and tempting a breakdown of order. This is accomplished, however, by compounding the meandering irregularity prevalent in these canvases with a geometric scheme, for a deliberate confounding of approaches to drawing. Wherever meander and geometry are superimposed, the result is a close-knit reticulation; whenever a parallel arises, a visual glut in the skein of parallel lines forces the issue. To bring contrary procedures in conjunction is to invite havoc and disheveled spacing. Yet a grammar of relations maintains itself throughout: red lines parallel, lines merged, lines crossed.

From the rippling line accumulates a subtlety that is more than an erratic wobble. The line's adventure is singular from canvas to canvas, as Siena is determined not to repeat himself, to take the givens of drawing for granted. *Ssonsunurrhth* gives us raveling linear skeins all in tumult, but *Converbatron* (2018; p. 34) contrives its opposite: the linear meandering remains compartmentalized and contained within a distinct diaper pattern. If the periphery is the object to which the rest of the lines respond, they still may not cross and rarely merge, for a distinctness that amounts to legibility graphically sustained.

The significance of periphery in all these artworks is, of course, the potential for generating contour lines, and yet if we are scrupulous, the term "contour" does not truly fit Siena's oeuvre. Studio practice attaches great importance to developing the hand sensitized to finding the form by way of following the planes and slopes of the body of an object, not just an edge or boundary. A different technique from tracing an outline, proper contour drawing is deliberately slow and thoroughly experiential throughout. The celebrated exercises devised by the once-famous art teacher Kimon Nicolaides include what he called "blind contour drawing": the student held pencil to paper but was not allowed to look and thus had to rely on topographically locating a body's planes within the bounding edge of the paper, certainly not confining the human body to its mere shape. Drawing this way induces viewpoints and planar intersections, which are responsive to the figural object that is the cause of it all.

Contour drawings are common practice in civil engineering, in which the practice of mapping a terrain requires a diagram with each line corresponding to the uniform slope taken from the ground. In this scheme, contour lines complete the circuit and close. Lines cannot cross for that would show contradictory information.

Siena's practice is an amalgam of the outline and the meander. The outline sets the terms of separation and boundary, with clarity of structural procedure to follow; the meander posits curiosity, with the surprise of finding itself in predicaments that only ingenuity can resolve. If these are considered ways of drawing, then Siena's current practice combines aspects of both, yet with an act of accumulation, a self-contouring terrain.

Thus, James Siena has introduced variable change in this body of work; nonetheless, his methodical ways substantiate the algorithms by which we know him. The fractal imitations from which the artist derived his method belong to the field of inquiry and commitment known from the post-Minimal pursuit of information systems as the basis for inspiring objective drawing. Executed procedurally, drawing becomes here its own logic, productive of imaginative worlds.

Scanning these canvases for pattern, the viewer perceives a frantic delicacy that sustains itself entertainingly. *Yes, but*. To scan for pattern misses the point of the technical process that takes abiding interest in how, as Philip Rawson, former curator of the Gulbenkian Museum of Oriental Art, might say, "Line takes up the sense of another line in parallel." As simple a formula as lines in parallel can show, the generative power of the grating of lines not-quite parallel entertains eccentric imitation, echo, and enfolding: an excess of which is quickly perplexing and a lure for fanciful imagery.

To become familiar with the technique is to experience the point of view of the maker, the artist.

So now, let's step closer to the works themselves.

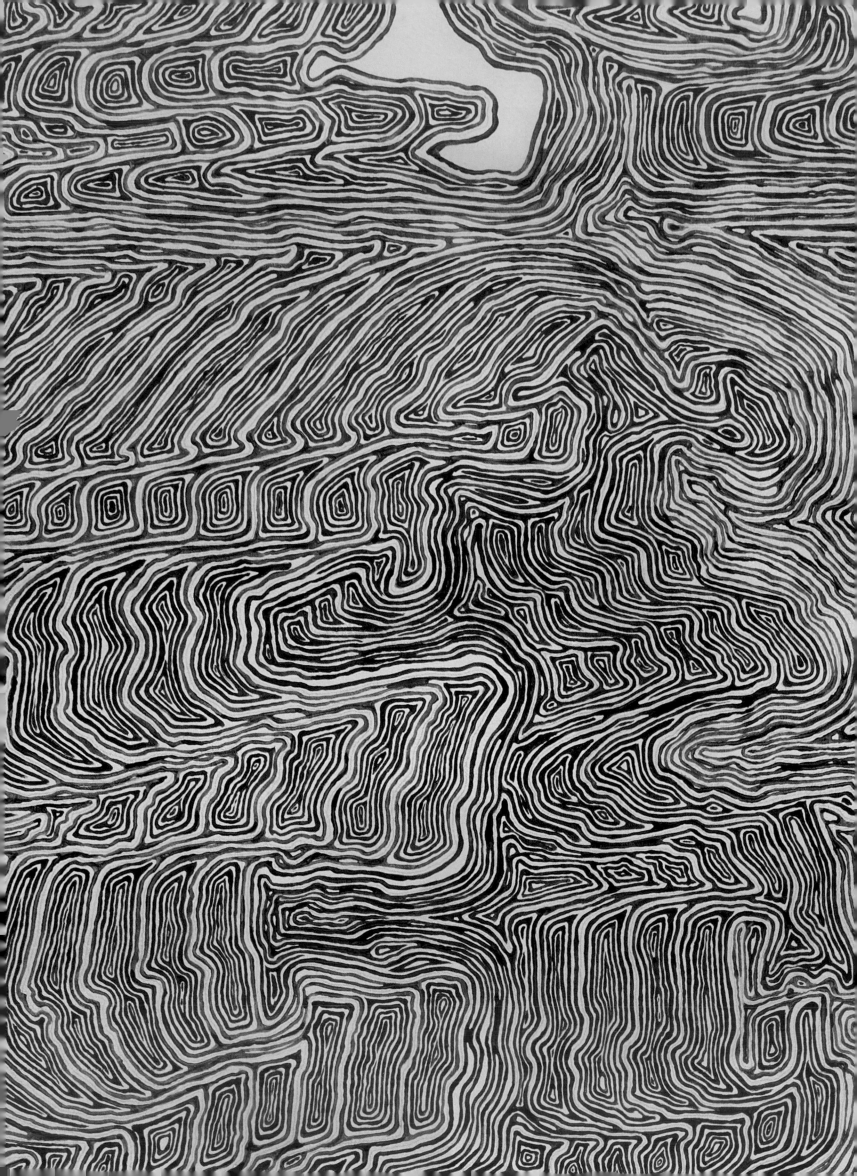

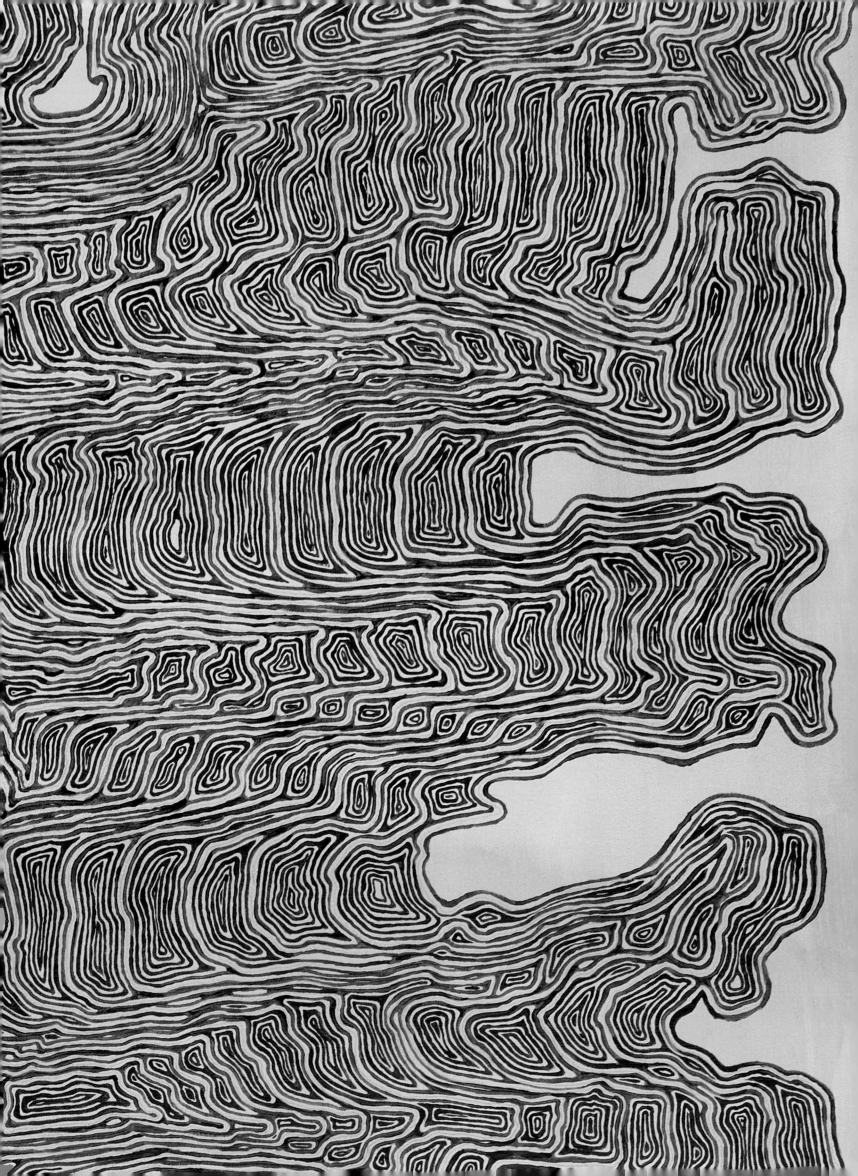

PERCUSSILATIVE ECHO, 2017–18
acrylic and graphite on canvas, 75 × 60"

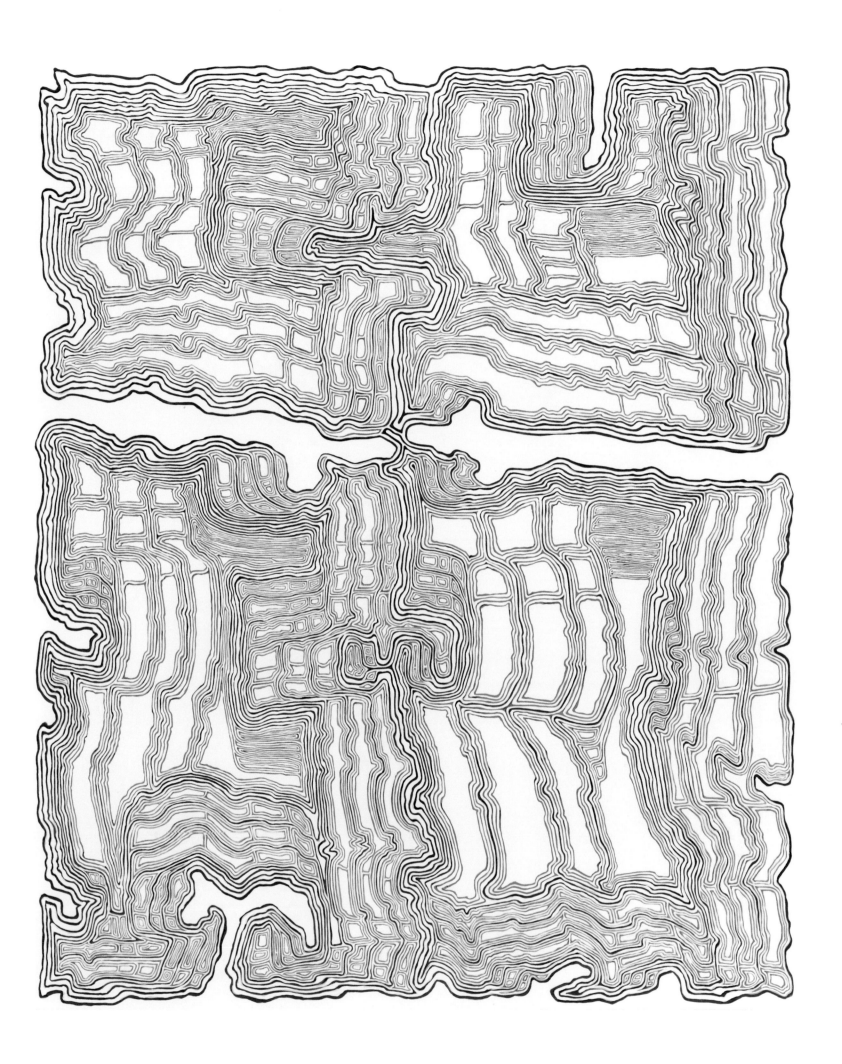

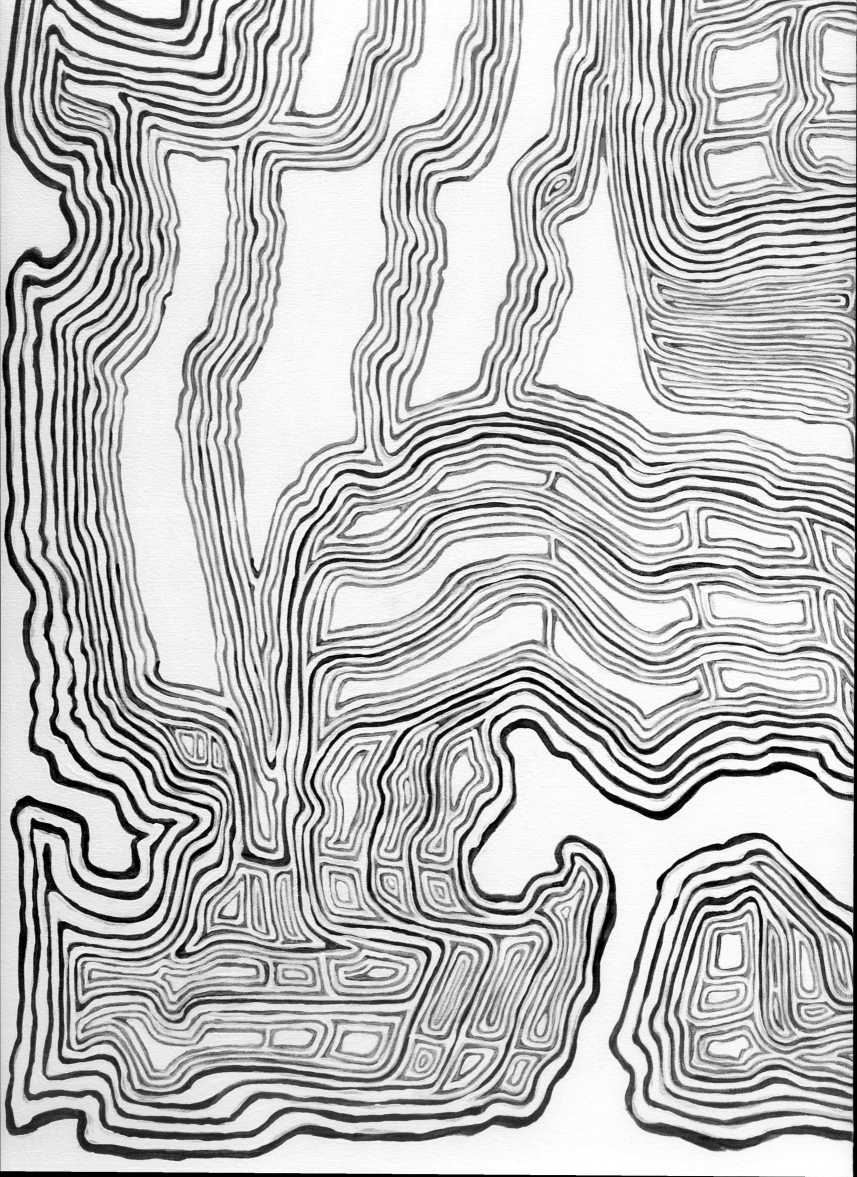

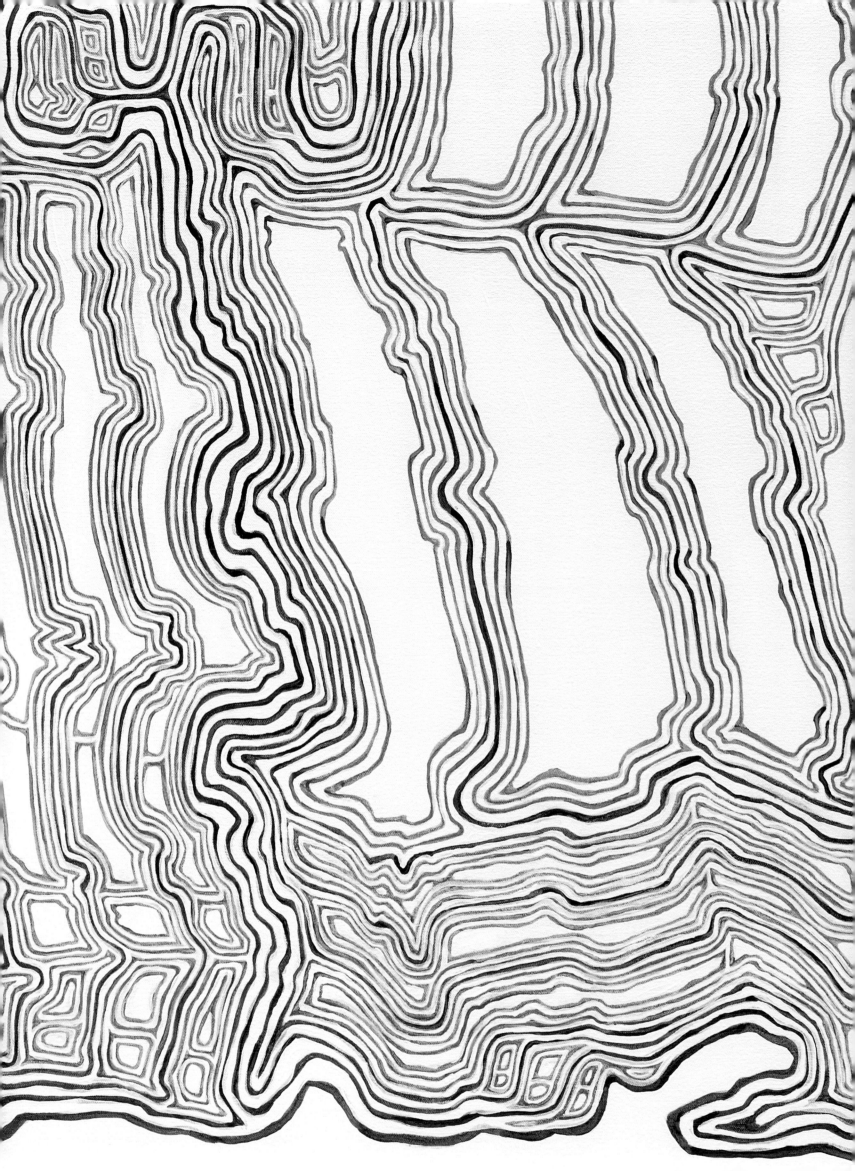

HEXSCILLOID, 2018

acrylic and graphite on canvas, 75 ¼ × 60"

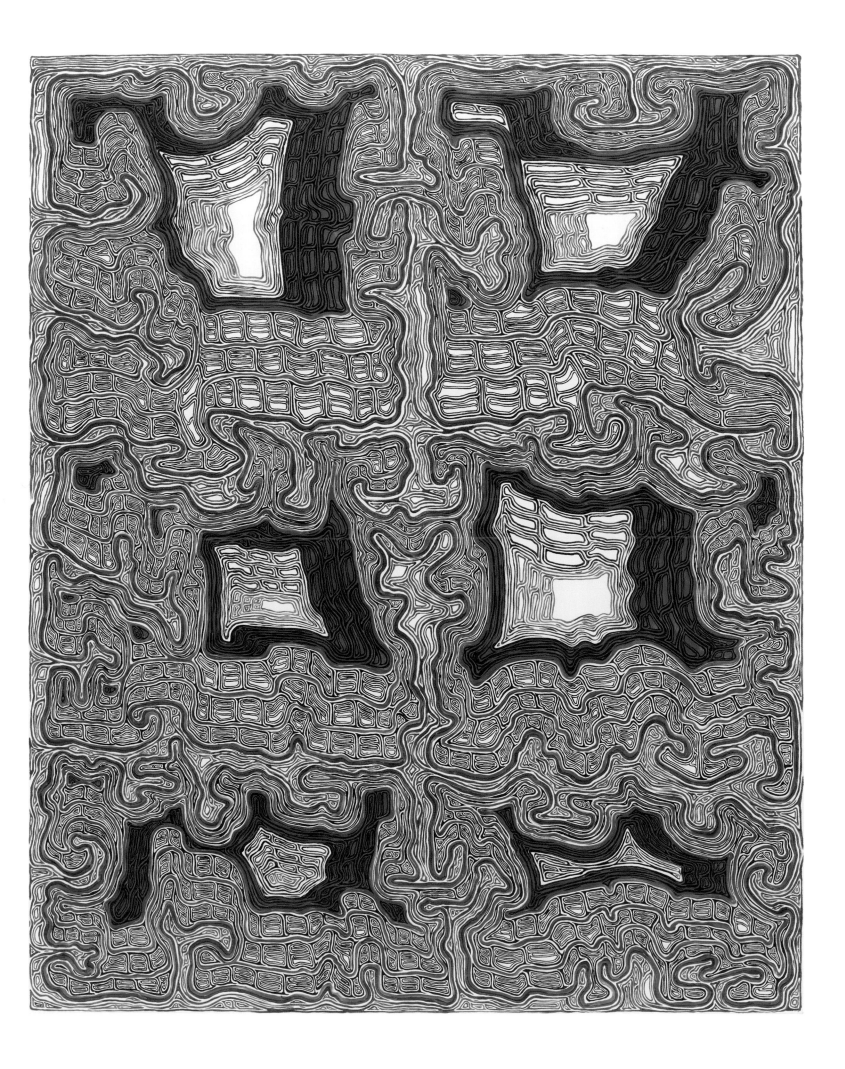

SPOOLSTONE, 2017
acrylic and graphite on canvas, 36 × 48"

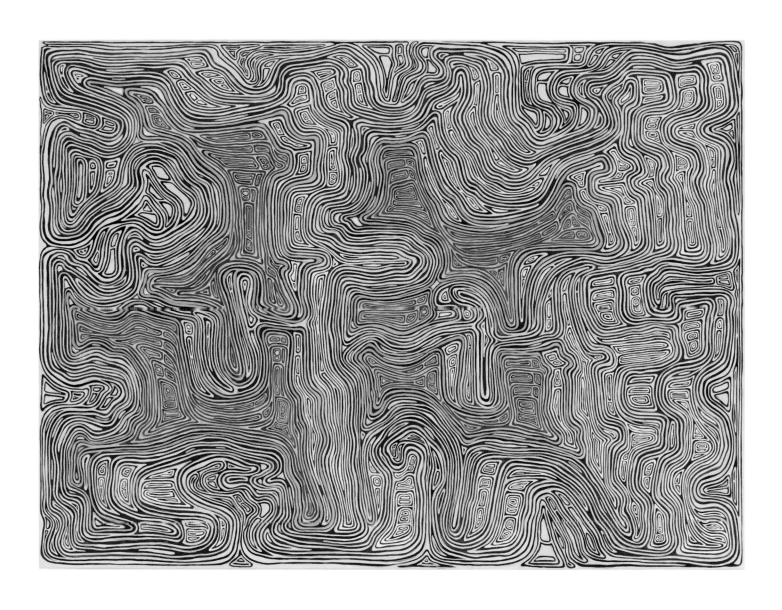

CONCORDULATION, 2017

acrylic and graphite on canvas, 75 × 60"

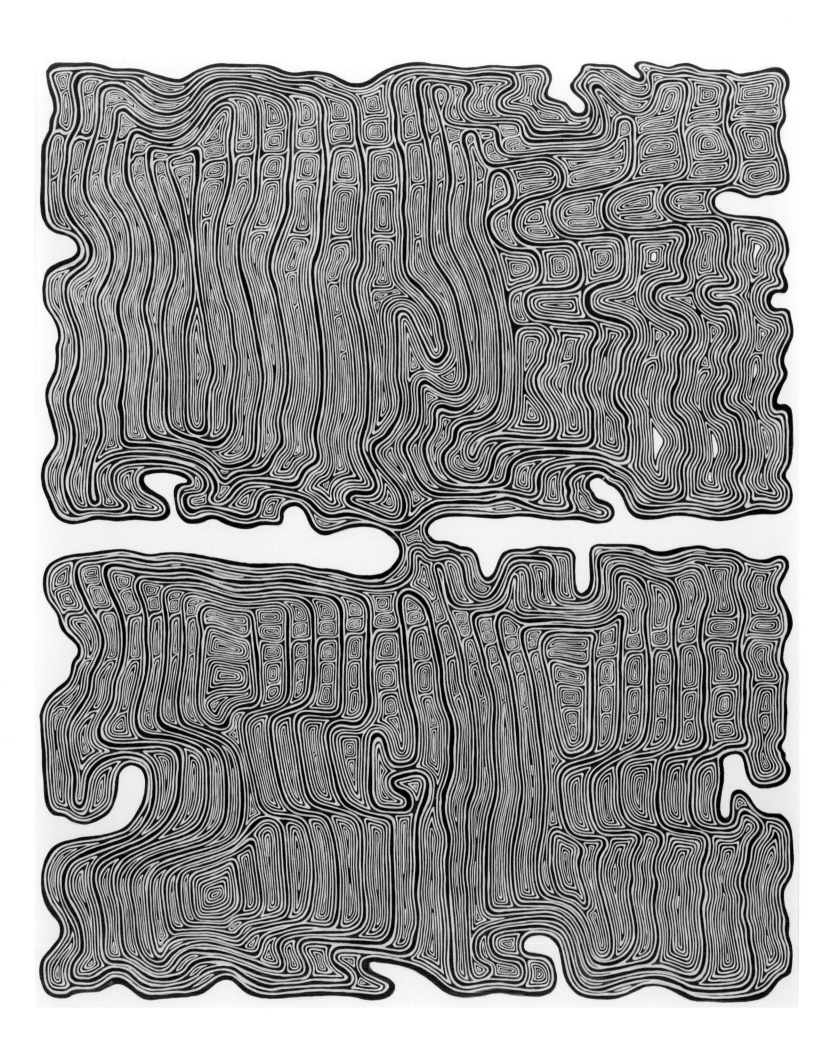

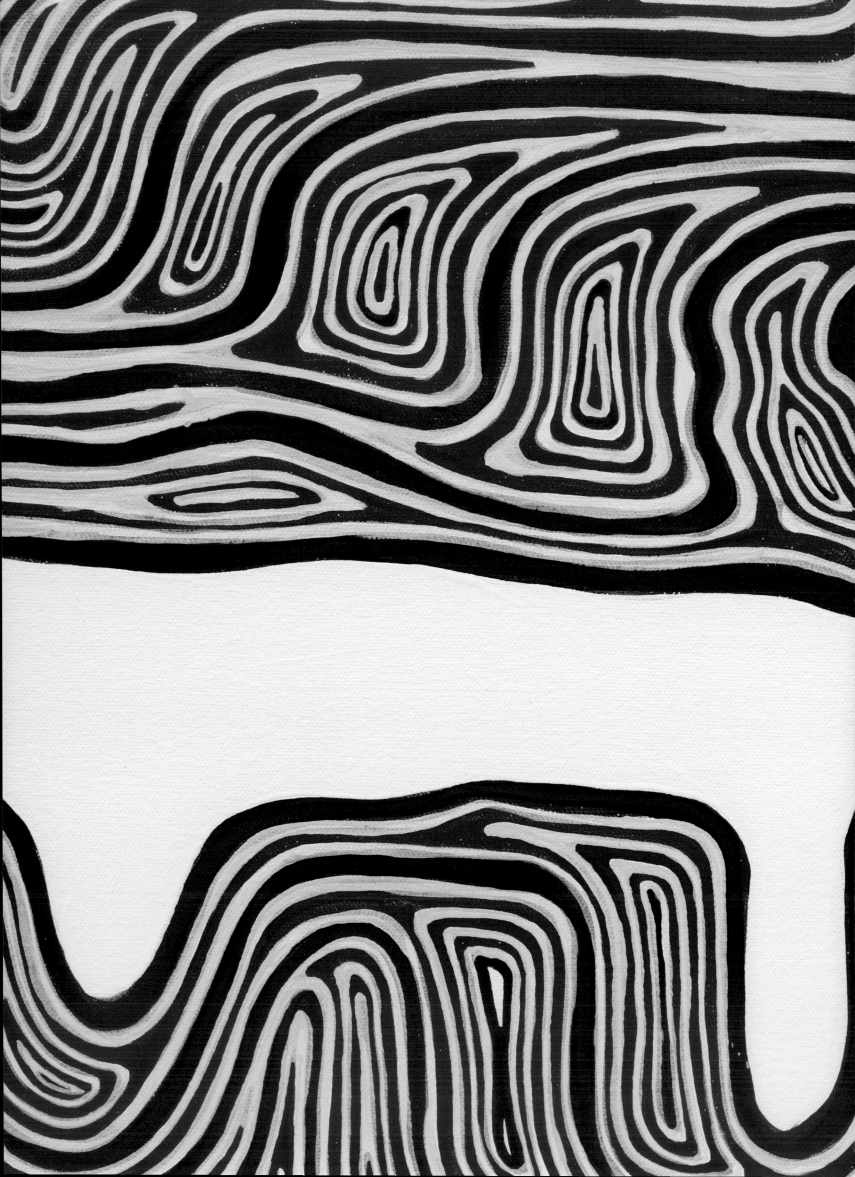

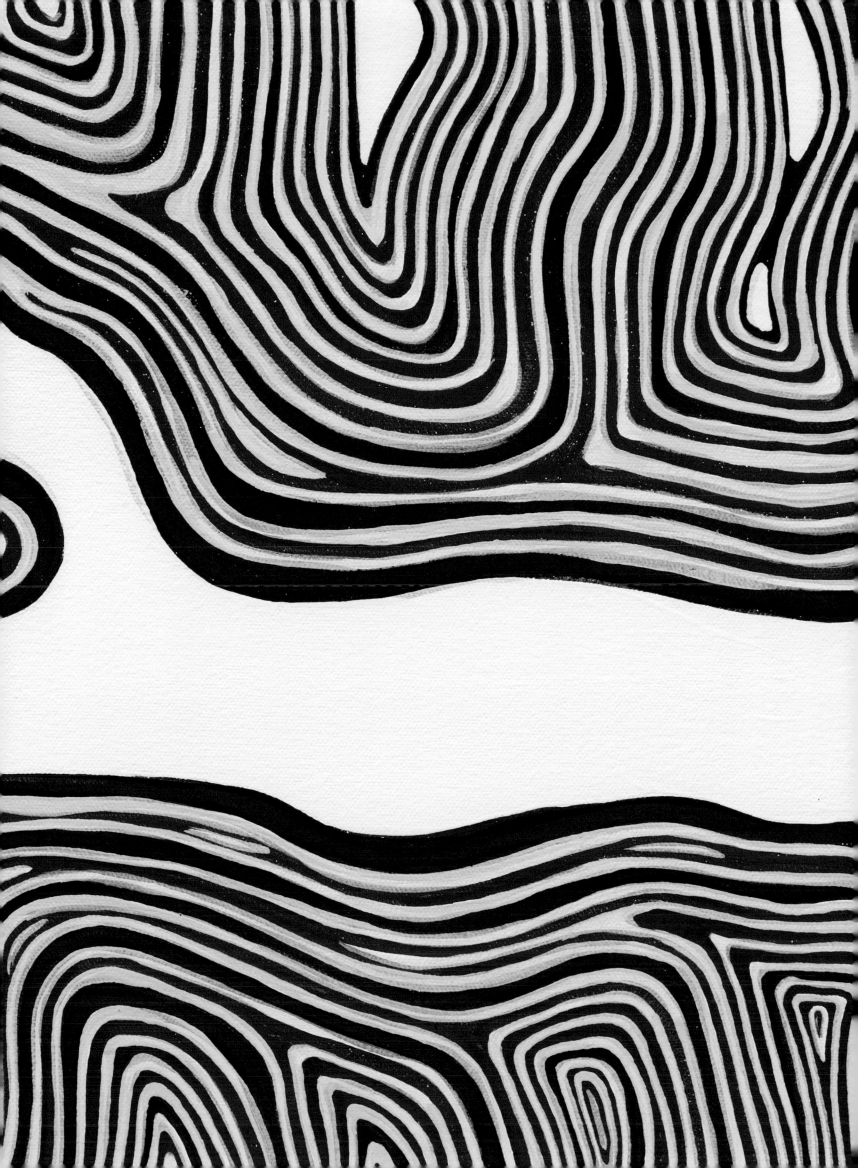

RETRRONR, 2018

acrylic and graphite on canvas, 90 × 70"

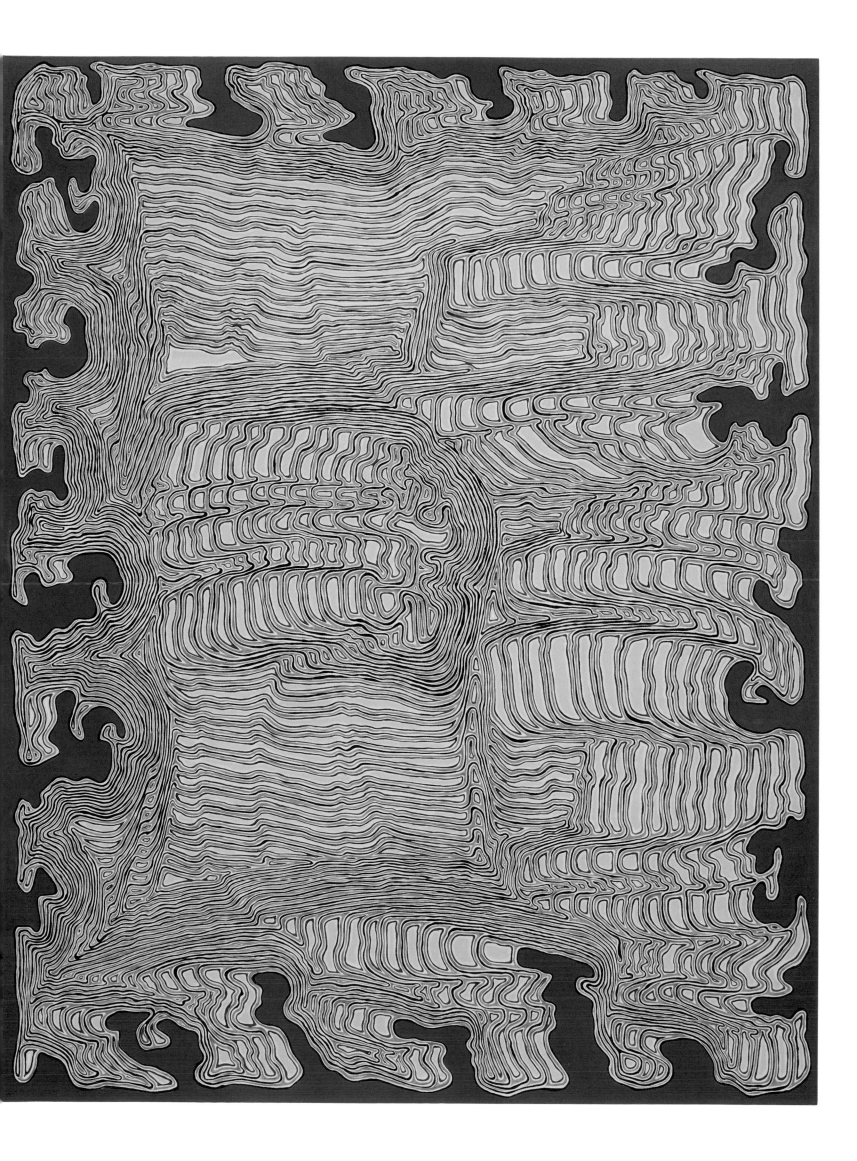

TNONDE, 2017–18

acrylic and graphite on canvas, 91 × 70 ¼"

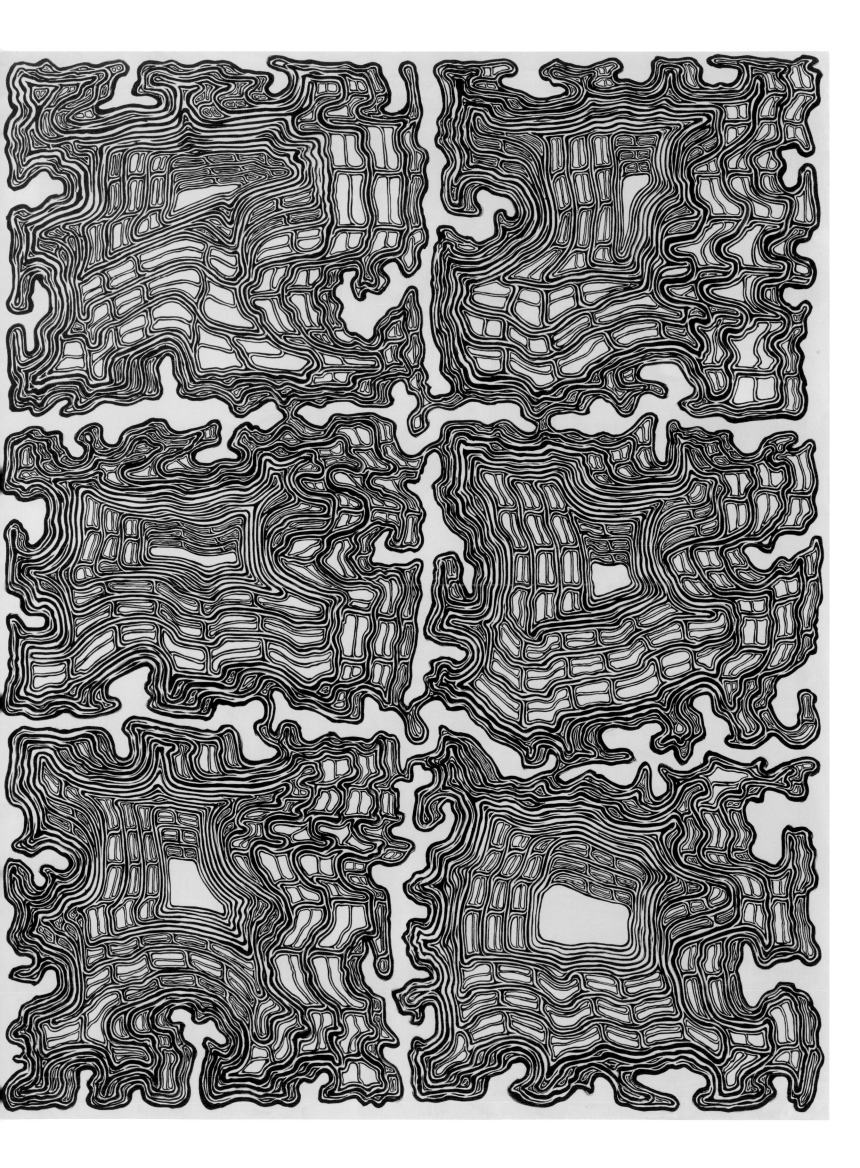

STRUNOSSC, 2018

 acrylic and graphite on canvas, 90 × 70"

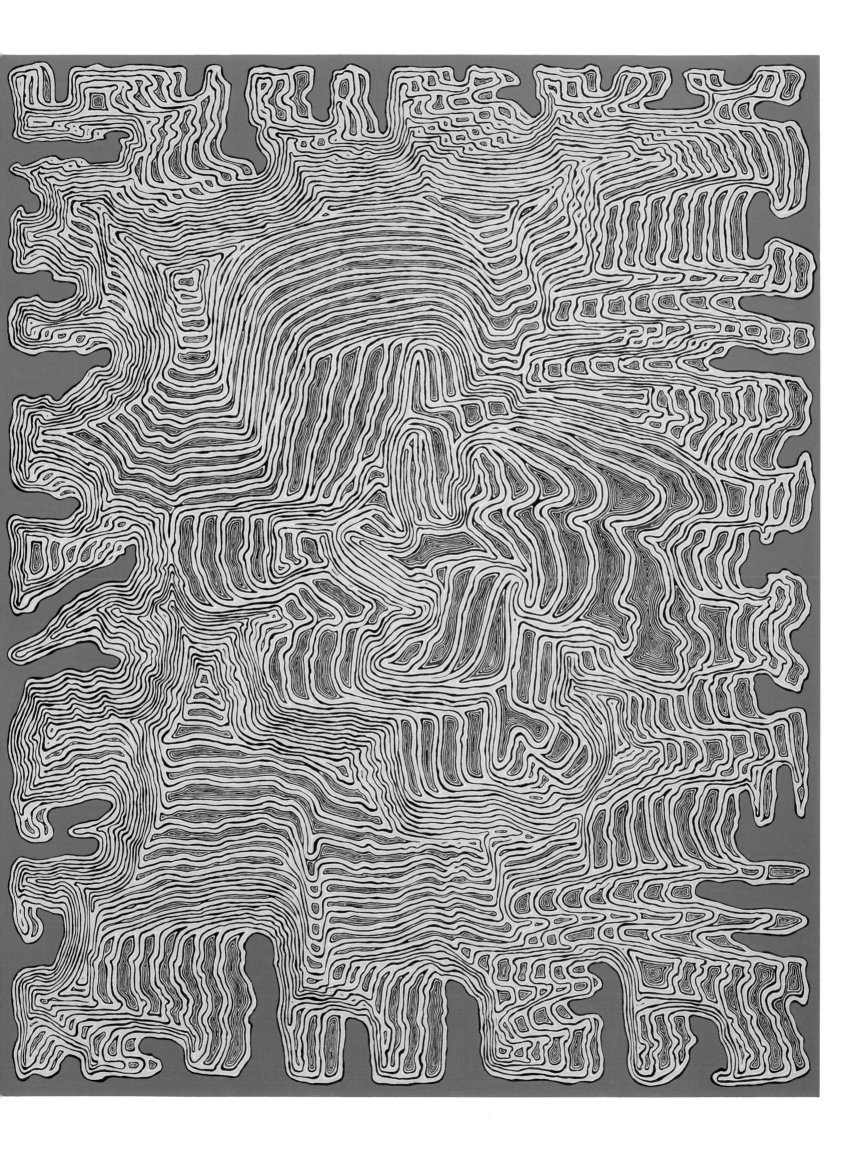

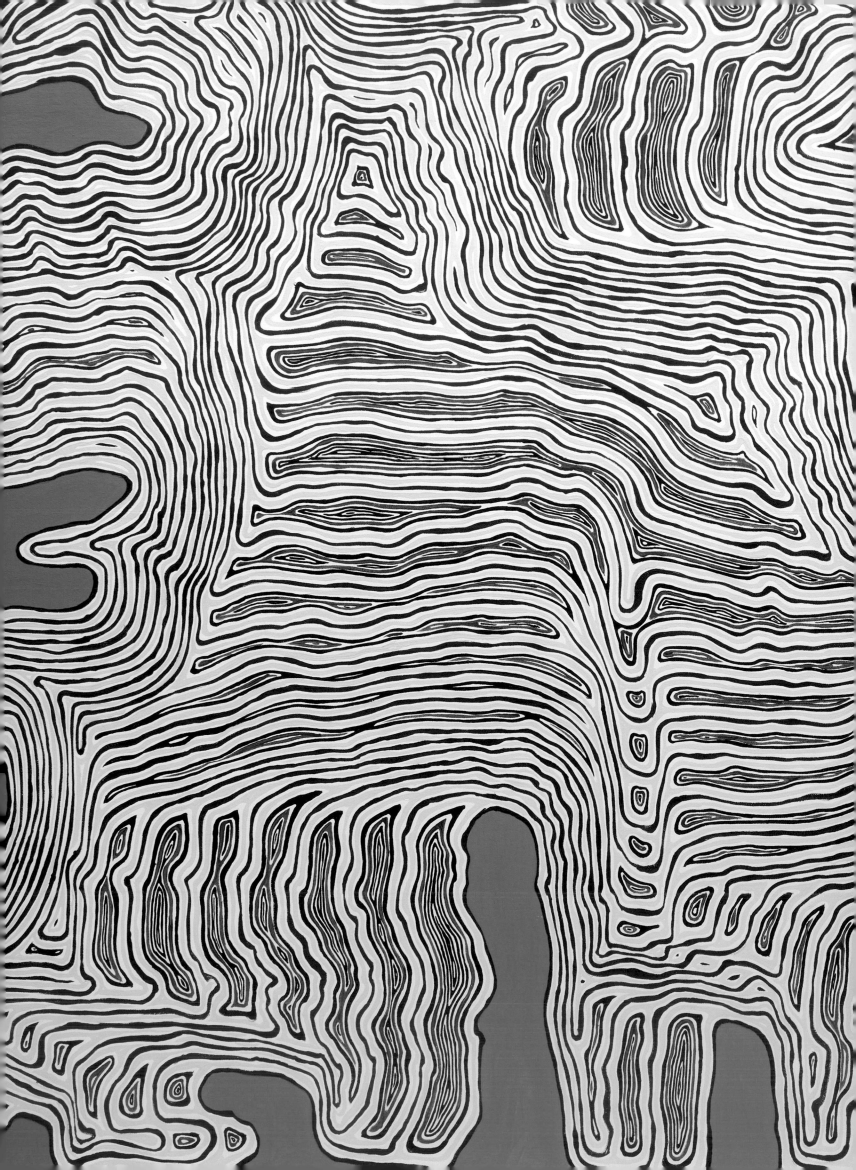

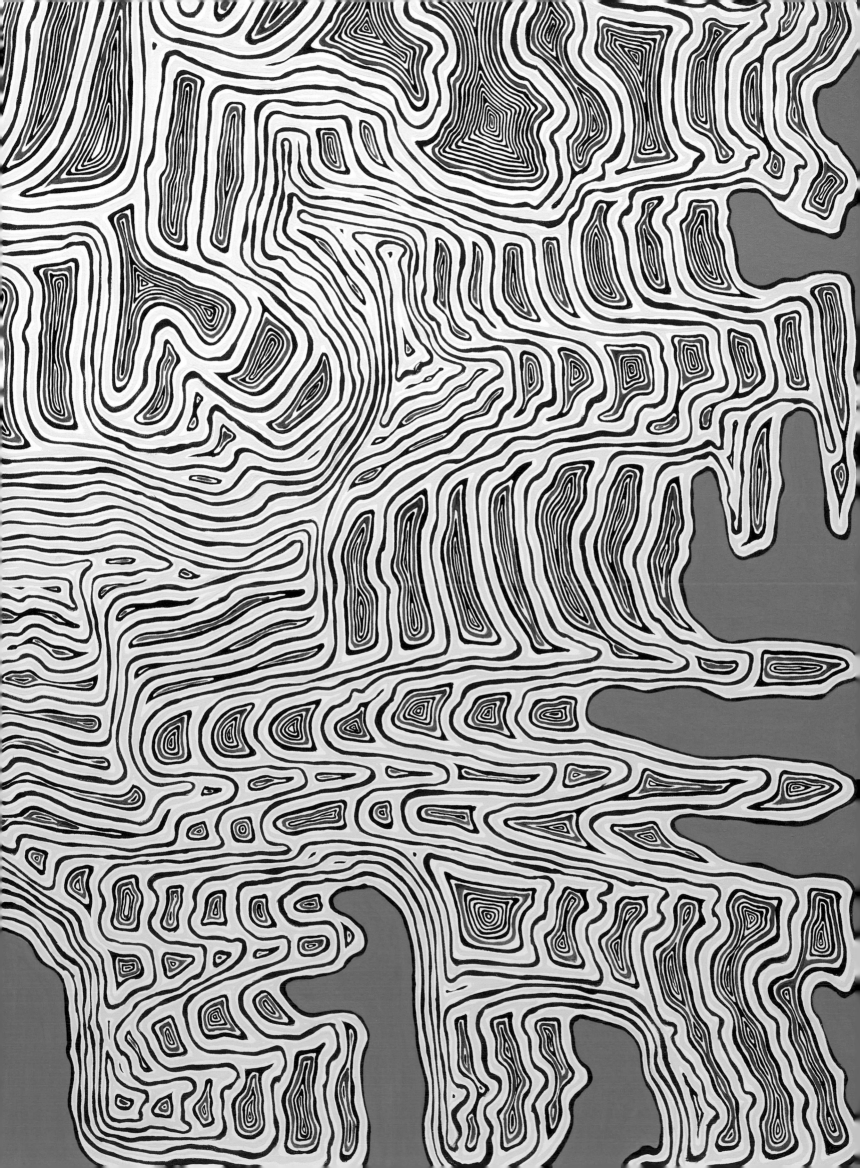

URRETRU, 2018

acrylic and graphite on canvas, 90 × 70"

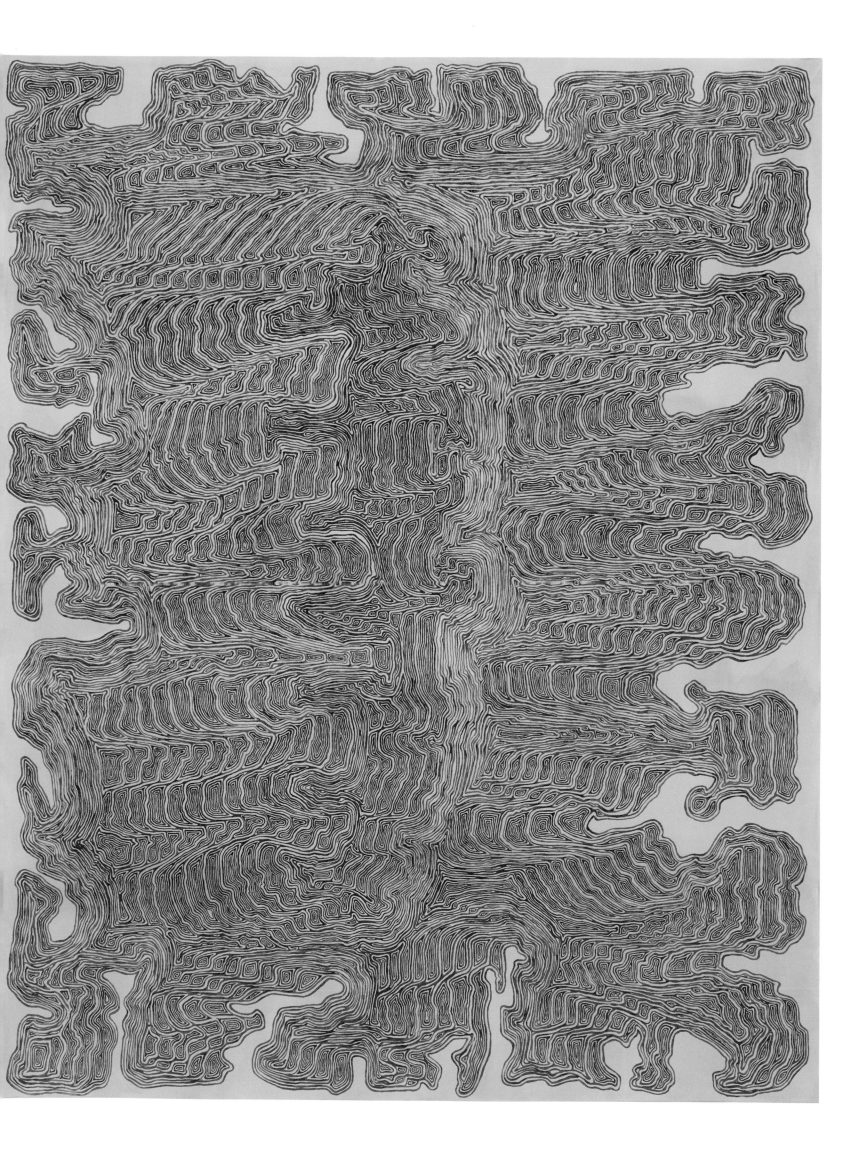

CONVERBATRON, 2018
acrylic and charcoal on canvas, 75 × 60"

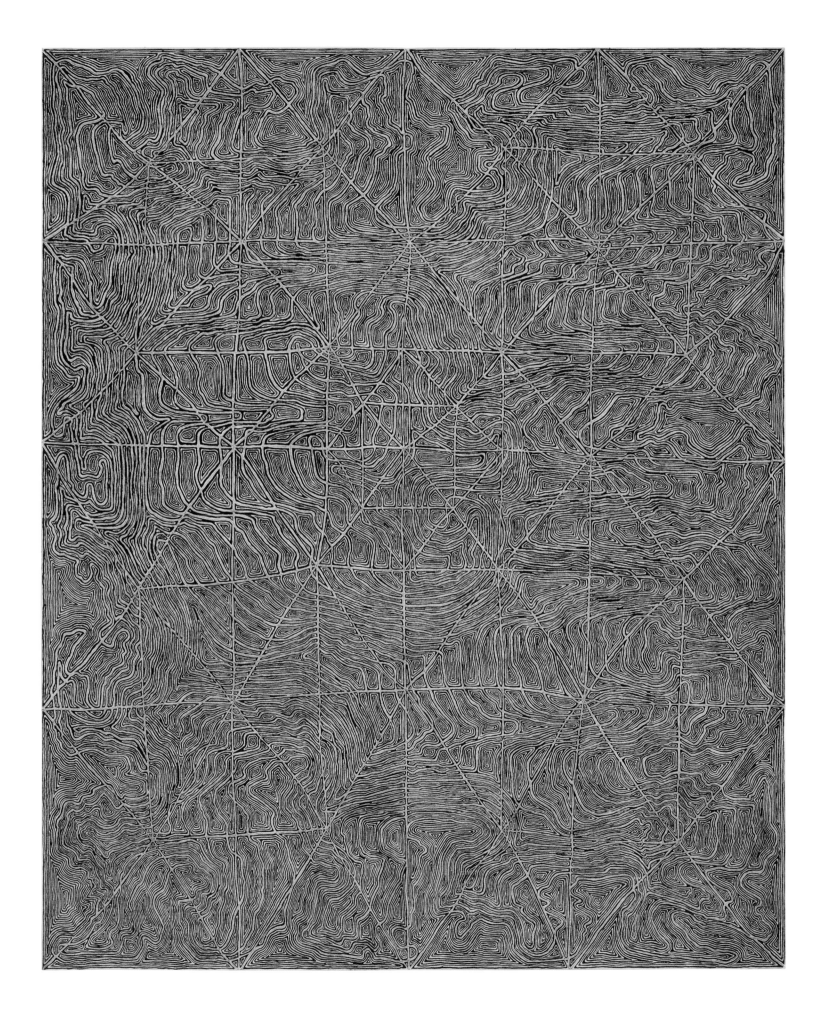

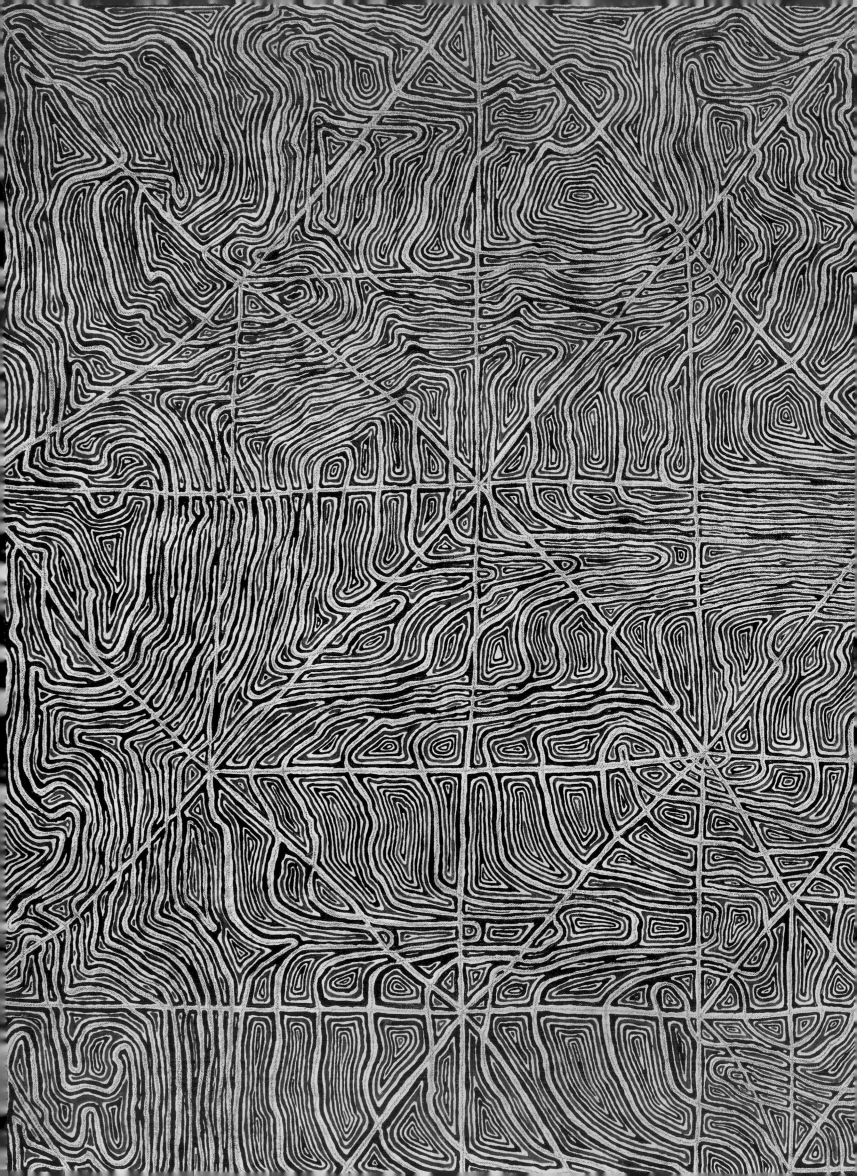

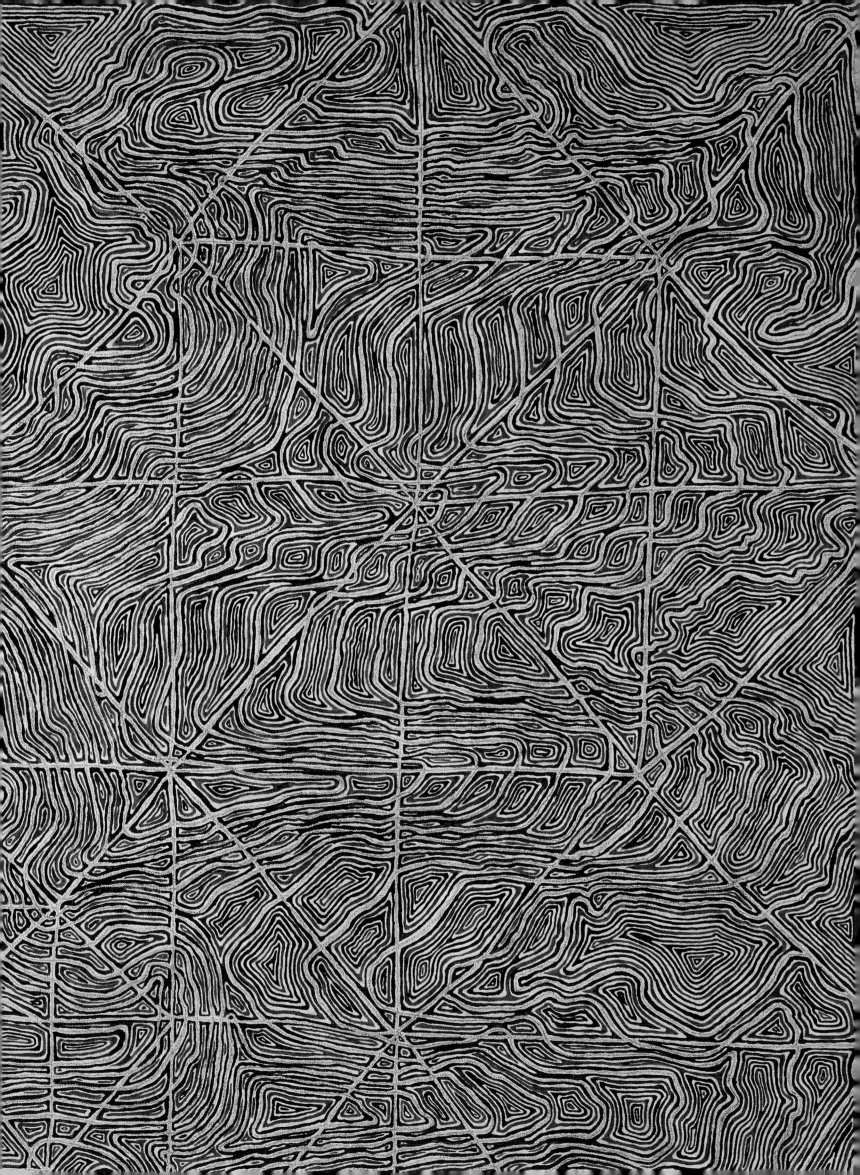

SSONSUNURRHTH, 2018
acrylic and charcoal on canvas, 90 × 70"

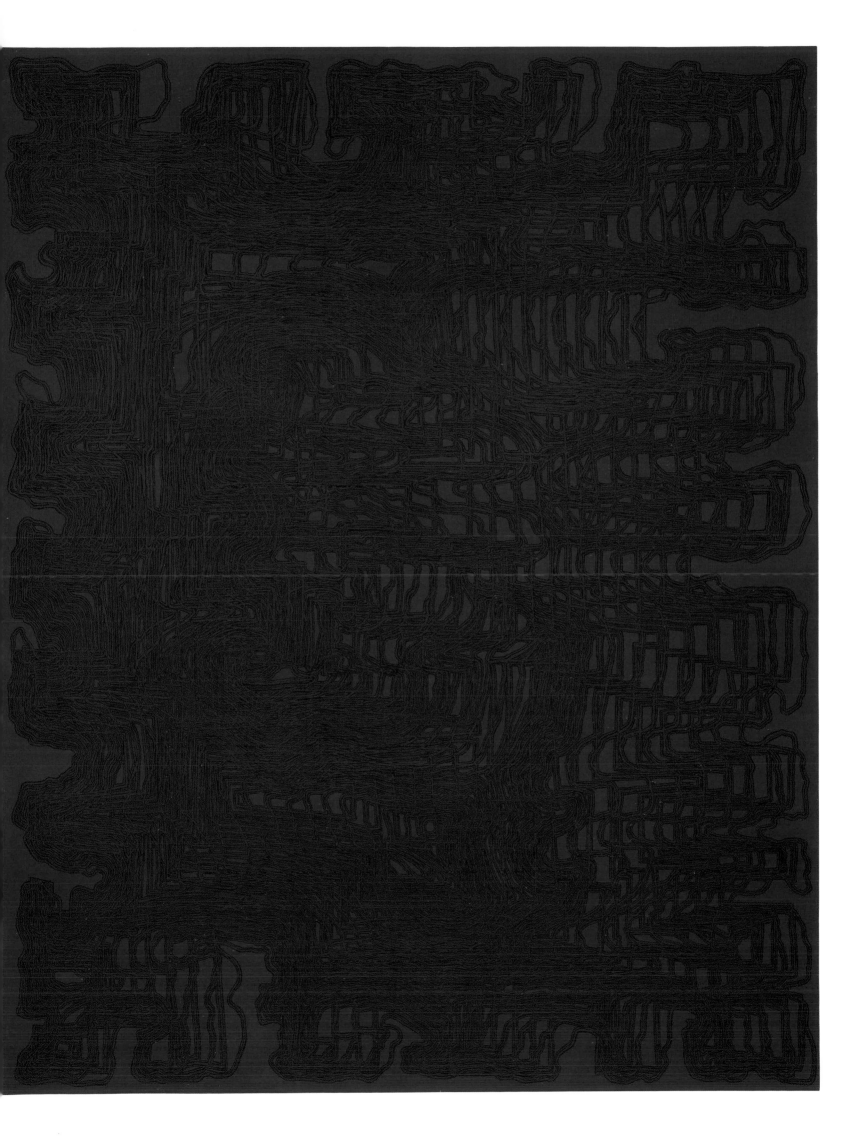

SRETRISTHS, 2018

acrylic and charcoal on canvas, 90 × 70"

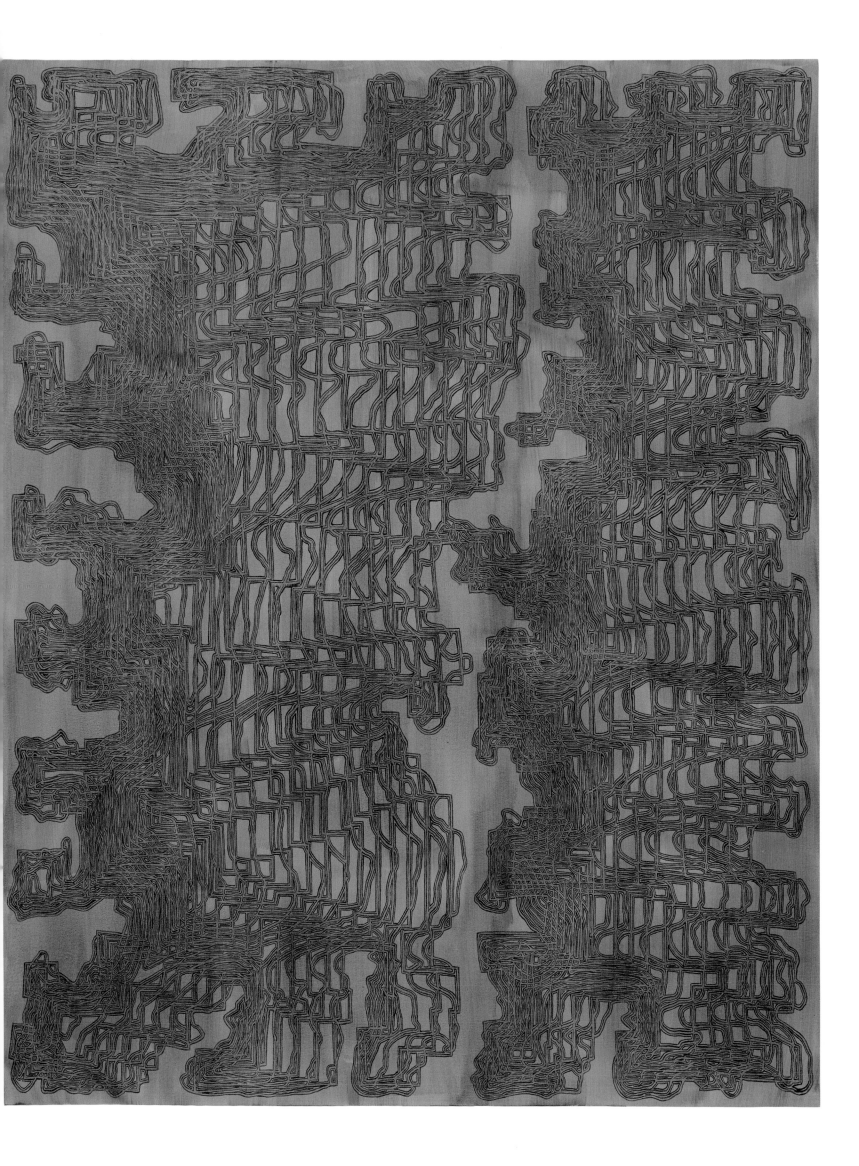

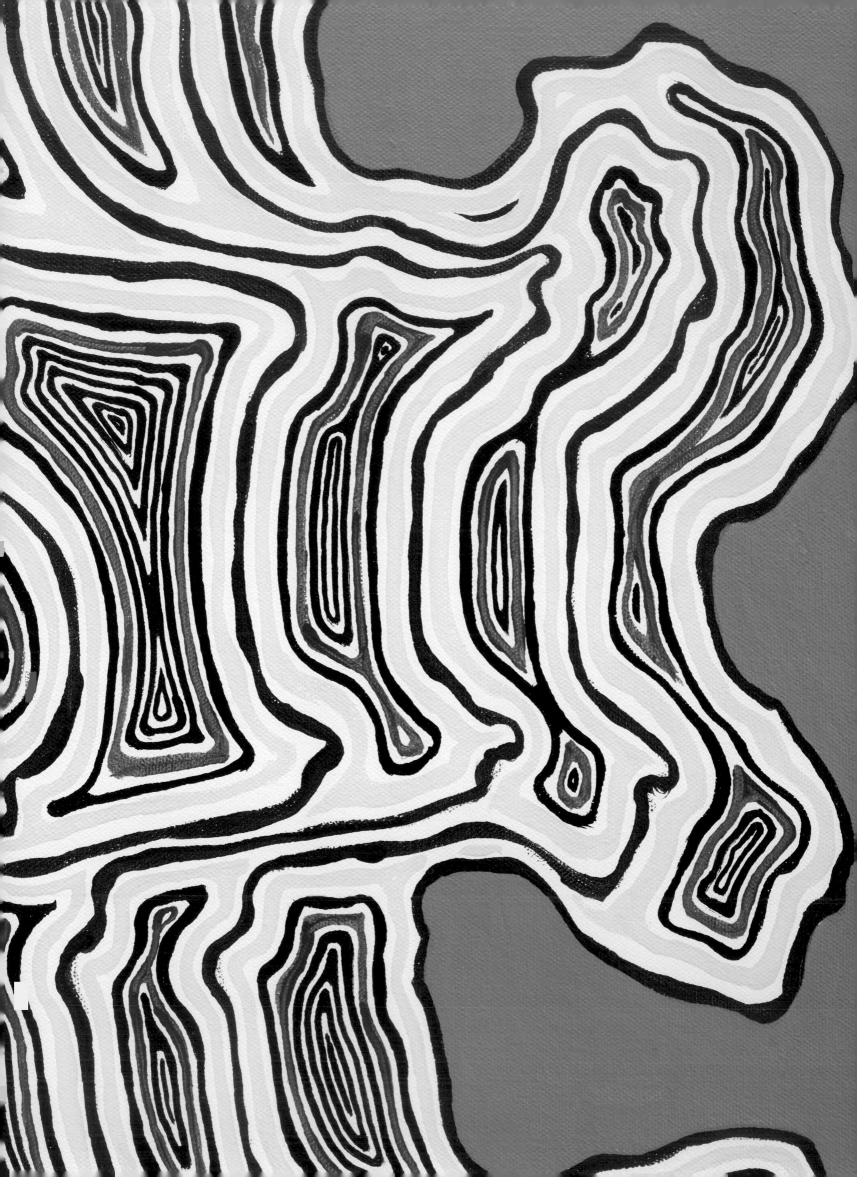

LIST OF WORKS

12 PERCUSSILATIVE ECHO, 2017–18
acrylic and graphite on canvas, 75 × 60"

16 HEXSCILLOID, 2018
acrylic and graphite on canvas, 75 ¼ × 60"

18 SPOOLSTONE, 2017
acrylic and graphite on canvas, 36 × 48"

20 CONCORDULATION, 2017
acrylic and graphite on canvas, 75 × 60"

24 RETRRONR, 2018
acrylic and graphite on canvas, 90 × 70"

26 TNONDE, 2017–18
acrylic and graphite on canvas, 91 × 70 ¼"

28 STRUNOSSC, 2018
acrylic and graphite on canvas, 90 × 70"

32 URRETRU, 2018
acrylic and graphite on canvas, 90 × 70"

34 CONVERBATRON, 2018
acrylic and charcoal on canvas, 75 × 60"

38 SSONSUNURRHTH, 2018
acrylic and charcoal on canvas, 90 × 70"

40 SRETRISTHS, 2018
acrylic and charcoal on canvas, 90 × 70"

Catalogue © 2018 Pace Gallery
Works of art by James Siena © 2018 James Siena
Text by Marjorie Welish © 2018 Marjorie Welish

All rights reserved. No part of this publication may be reproduced or transmitted in any form or by any means, electronic or mechanical, including photocopying, recording, or any information storage and retrieval system, without permission in writing from the publishers.

Every reasonable effort has been made to identify owners of copyright. Errors or omissions will be corrected in subsequent editions.

Photography:
Kerry Ryan McFate; pp. 21, 22–23 (detail)
Mark Waldhauser and Kerry Ryan McFate; pp. 4, 19, 27
Mark Waldhauser; pp. 10–11 (detail), 13, 14–15 (detail), 17, 25, 29, 30–31 (detail), 33–35, 36–37 (detail), 39, 41, 42 (detail)

Design: Tomo Makiura and Tara Stewart
Production: Pace Gallery
Color correction: Motohiko Tokuta
Copyediting: Kamilah Foremam

Typeset in Alegreya Sans and Alegreya by Tara Stewart

Printing: Meridian Printing, East Greenwich, Rhode Island

ISBN: 978-1-948701-13-6